Up Your Ass

Up Your Ass

or

From the Cradle to the Boat

or

The Big Suck

or

Up from the Slime

Valerie Solanas

Sternberg Press

I dedicate this play to

ME

a continuous source of strength and guidance,
and without whose unflinching loyalty, devotion,
and faith this play would never have been written.

additional acknowledgments:

Myself—for proofreading, editorial comment, helpful
hints, criticism and suggestions, and an exquisite job of
typing.

I—for independent research into men, married women,
and other degenerates.

CHARACTERS

(in order of appearance)

Bongi Perez

PASSERSBY

SPADE CAT

WHITE CAT

ALVIN KOONTZ

WAITRESS

GINGER

RUSSELL

MISS COLLINS

SCHEHERAZADE

TEACHER

ARTHUR

BOY

TIME:
The present;
afternoon.

PLACE:
A large
American
city;
the sidewalk.

(BONGI PEREZ, dressed in khaki pants,
a loud plaid sports jacket, and tennis shoes,
is loitering on the steps of the apartment
building where she lives and next to which
is an elegant restaurant with a sidewalk patio.
A broad passes by.)

BONGI: *Hell*'o, Beautiful.

(The broad ignores her.)

Stuck-up bitch.

(A second broad passes by.)

Hell'o, Gorgeous.

(The broad ignores her.)

**Oh, my, but aren't we the high-class
ass. You got a twat by Dior?**

(A third broad passes by. BONGI blocks her
path. The broad moves to the side to bypass
BONGI, but BONGI moves with her, still
blocking her. The broad moves to the other
side, but again BONGI blocks her.)

Give me a kiss and I'll let you pass.

BROAD (*calling in whiny exasperation to her male escort a few paces behind*): Morton, this girl, she won't let me pass.

MORTON (*coming up*): Come on, come on, Girlie, let her pass.

BONGI: Hey, Jim Dandy to the rescue.

(She continues to block the broad's path.)

MORTON: If this is your idea of humor, let me assure you it's not.

(He pushes BONGI aside.)

BONGI: Ooooo, you're so big and strong, Morton.

(He and his broad stalk up the street.)

(*hollering after them*) **She's all yours, Jim Dandy; she's really not my type.**

(Two cats, one white and one spade, who had been watching the action from a few feet away, approach.)

SPADE CAT: Can I be your type for just one night? We'll have a boss time together; I'm a

man of deeply passionate heart and soul.

BONGI: Heart and soul, my ass. All your passion's concentrated in your dick.

SPADE CAT: But that's some mighty fine dick. You should try it sometime.

(A broad passes by.)

WHITE CAT: Hey, dig the ass on that.

SPADE CAT: I needn't be reminded to dig the ass on that. That's a mighty fine ass.

(He looks at BONGI's ass.)

And yours ain't at all bad. You may consider that a high compliment, being I'm a connoisseur of asses. There's nothing dearer to my heart than a big, soft, fat ass.

BONGI: Because it matches your big, soft, fat head?

WHITE CAT: You have no grounds for sarcasm; you're in the same Triple-A club we are— Amalgamated Asswatchers of America.

BONGI: You're wrong—I'm not a watcher; I'm a woman of action.

WHITE CAT: You think I'm not a *man* of action? See this chick coming along? Watch me move in.

(He approaches the flashy, wild-looking chick who's walking by.)

BONGI: Why're *girls* called chicks? After all, *men* have the peckers.

WHITE CAT (*to chick*): Pardon me, Miss. Forgive this intrusion, but I seem to recall having seen you somewhere before.

CHICK: Beat it, Little Boy; go play with your yo-yo.

(She walks off to a store window a few paces down the street where she stops to look at the display.)

SPADE CAT: Man, you ain't moving in, out, or sideways; you're standing still. You guys don't know how to operate. You gotta have finesse; you gotta be smooth, suave. Now, step aside and let a *man* operate.

(He approaches the chick.)

Good evening, Goddess. Forgive what may sound like mere hyperbole, but to me you *are* a goddess.

CHICK: I can well understand your reaction; you've captured the inner me. Is that Boy Scout over there a friend of yours?

SPADE CAT: A mere acquaintance, but enough of an acquaintance for me to know he's not at all the man for you; his technique's as washed-out as his skin.

CHICK: And yours's as intense as yours?

SPADE CAT: You're perceptive.

CHICK: It just might be interesting. You strike me as a man who may very well appreciate the finer qualities of a woman.

SPADE CAT: I am, indeed; I'm a connoisseur of finer qualities. Shall we adjourn to my pad where we can peruse these qualities at leisure?

CHICK: Love to.

(They walk off together, making get-acquainted conversation as they go.)

WHITE CAT (*while walking off*): I may as well turn in my yo-yo; all the swinging chicks're either queer or they go with spades. A white man doesn't stand a chance nowadays. What're we stuck with? All the fish.

(He exits.)

(A nicely dressed, middle-aged man walks by, discreetly ogling BONGI as he passes her.)

BONGI: Hey, Joe, you like to see my seester?

MAN (*stopping*): Why, sure I'd like to see your sister—if she's as pretty as you; I have an eye for the ladies.

BONGI: What's the other eye for? Men?

MAN: You're as pretty as a movie star.

BONGI: I *am* a movie star; I star in movies for stag parties. But I've got professional integrity—I only work for the

top directors.

MAN: You wouldn't, by any chance, know where I could get some of those movies, would you?

BONGI: What do you want with stag movies when you've got me?

MAN: *Have* you? *Do* I have you?

BONGI: Sure you do. Anytime.

MAN: How 'bout your sister?

BONGI: What's with this sister bit? You got me. Isn't that enough?

MAN (*apologetically*): Yes, yes, you're just fine. I didn't mean any offense.

BONGI: Okay, forget it; I'm easy to get along with.

MAN: Tell me something—why me? Why'd you approach me? You must've sensed something unusual.

BONGI: *Sensed* it! I was *overwhelmed*

**by it. Any woman can see you're
a ball of fire.**

MAN: So I've been told. Women do
seem to have a way of detecting
the rake in me.

**BONGI: So that's what that bulge in
your pants is—a rake.**

MAN: It'll rake you right over
the coals—it's red hot.

BONGI: I'm all agog with anticipation.

MAN: I'm a little agog myself.
Why don't you join me for a drink?

**BONGI: I'm gonna join you for more
than a drink; I'm gonna join you for
dinner. We're gonna eat right in there**
(*indicating next-door restaurant*).

MAN: But that place's terribly expen-
sive. Really, what I had in mind was
a drink, maybe two, apiece. I really
can't afford...

**BONGI: Aren't you the big provider, the
big breadwinner? Well, I'm gonna give**

you a chance to lay out some bread; I'm gonna help you fulfill yourself as a man.

MAN: If I buy you dinner, will that lead to anything? You won't just eat and run?

BONGI: From you? A red-hot fireball like you?

MAN: No, I don't suppose you would; a good man nowadays's too hard to find. All right. Let's go.

(While walking toward the restaurant he takes BONGI's hand; she pulls it away; he takes it again, and again she pulls it away.)

BONGI: What do you want to hold hands for? We're not going steady.

MAN: I guess it's just the romantic in me.

BONGI: But what's the point? Does it feel good? Are your sex organs in your hands?

MAN: They might as well be—when I

9

feel your hand against mine I get all shivery.

BONGI: That's because you have a short-circuited nervous system—all roads lead to Rome, and all a man's nerve endings lead to his dick.

(They seat themselves at a table. A waitress gives them menus and water.)

MAN: I still can't get over your astuteness singling me out from all the men on the street, but I'm certainly glad you did. Oooo, you're a nice, tender one.

(He's sitting very close to her, and he slips his hand into her shirt.)

Let me feel your plump little booby.

BONGI: Look, Charley...

MAN: Alvin. Alvin Koontz.

BONGI: Get your goddamn hand off my boob.

ALVIN: You know, you really should try to

watch your language; it pains me to hear a woman curse.

BONGI: Would you please keep your hand off my boob?

ALVIN: Come on, nobody's looking. Just a fast little tweak.

BONGI: Get your apey hand off my boob, or I'll kick you in your big, fat, hairy shins.

ALVIN: All right, all right; I'll try to be a good boy.

BONGI: Good. Now let's have some nice ladies-and-gentlemen conversation.

ALVIN: All right. Tell me about yourself. Are you happy?

BONGI: I'm not acutely *un*happy— mainly because I have so many engaging memories to feed on. (*Nostalgically.*) **I remember the time I was stomping up and down on this masochist's chest, and I had to charge him an extra ten bucks 'cause I broke 'em. This faggot, Poupette, that introduced me to him,**

offered to stomp on him, but he only wanted a woman. He said: "What do you think I am? A pervert?"

(She jumps up.)

Here it is, folks—the Chest-Stepping Stomp.

(She does a scrapping, chest-stepping stomp.)

I've got a real feel for chest-stepping.

WAITRESS (hurrying over): *Listen, where do you think you are? Please be seated, or I'll have to ask you to leave.*

BONGI (sitting down): Ah, me. Another day, another chest. Hey, remember that shy john in *Never on Sunday*? You know why he was so shy? He couldn't get up enough nerve to ask her to stomp on his chest, so he settled for second best—they had the Bazouki band come in, and they all pissed all over him. Then I remember old Quick-Trigger McGrew—he hadn't finished pulling his pants down when he started pulling them back up again. (Sighing.) Ah, memories, memories.

ALVIN: I take it you'll do just about anything.

**BONGI: Well, nothing *too* repulsive—
I never *kiss* men.**

ALVIN: Nevertheless, I'd sure like to become part of your memories.

BONGI: I think that could be arranged for a slight fee.

ALVIN: Feel? I never paid for sex in my life!!!

BONGI: I'll bet you've never had any either.

ALVIN (*controlled indignation*): For your information, women pay *me*. I happen to be dynamite in the sack. I've been highly commended on several occasions for my distinctive performance.

BONGI: I'll say one thing for you, Harry...

ALVIN: Alvin.

BONGI: ...you got a wild imagination.

ALVIN (*furious*): Why, you... you dirty... (*Gradually acquiring control.*) I usually restrain myself from

13

brutal frankness, but you've asked for this; now you're gonna get it— (*With slow, deliberate, emphatic articulation he devastates her with the ultimate insult.*) You—are not—the least—bit——SEXY.

BONGI: Calm down, Melvin.

ALVIN: Alvin.

BONGI: I was only kidding you. Didn't I single you out from all the men on the street?

ALVIN: Yeah, you did, didn't you?

BONGI: Didn't I tell you you're a red-hot fireball?

ALVIN: Yeah, I guess you did.

BONGI: So whatta you getting so up in the air about?

ALVIN: Yeah, you're right; you're right. I hope you don't think I'm just an old grouch. Actually, I have quite a light, playful streak in me that I keep sharpened up by a faithful reading of the more zestful men's magazines— *Tee-Hee, Giggle, Titter, Lust, Drool, Slobber,*

and, just for thoroughness, *Lech*, and I'm a connoisseur of fine living. I got me one of those revolving beds they feature in *Playboy*. That's really something. Get this: it's a huge, circular bed that rotates when you press a button, and there's all kinds of stuff built in around half the bed—radio, stereo set, bar, telephone, hot plate, refrigerator—and the beauty of it all is you never have to leave your bed; you just rotate yourself around to whatever you want. This is living carried to the very ultimate... (*Growing intensity.*) The bed becomes the center, the very hub of your life. Think of it... (*Carried away.*) Everything revolves around the bed. (*Coming back.*) I'd sure like to take you for a little spin in that revolving bed. Tell you what—I never pay for sex, as I said, but I'm willing to pay to let you have the opportunity of seeing me in action. It'll be an experience you'll never forget. Your head'll be spinning faster than the bed. Ah HAAAH. Now, what's the price tag?

BONGI: Well, for fifty bucks you get five minutes with a three-quarter-minute intermission. For an additional ten bucks I sneer, curse, and talk dirty. Then there's my hundred-dollar special, in which, clothed only in diving helmet and storm-trooper

boots, I come charging in, shrieking filthy songs at the top of my lungs.

ALVIN: That sounds delightful, but let's get back to the fifty-dollar session. Even that's a little steep for my pocketbook. Squooshy little thing as you are, I couldn't possibly go for fifty bucks.

BONGI: Then tell you what I'm gonna do: I'm gonna give you my bargain special at twenty-five bucks, and that's my final offer. Take it or leave it.

ALVIN: Fair enough. I'll take it. Now, when we leave here we'll sprint right on over to my place and dive—kaphloomp—right smack-dab in the middle of that big, soft revolving bed.

BONGI: No, we won't; I never go to men's apartments.

ALVIN (*deeply let down*): Oh. Well... That's okay then; we'll go to your place.

BONGI: No, we won't; I never bring men to my place.

ALVIN: Then we'll get a hotel room somewhere.

BONGI: No, we won't; I never go to hotel rooms with men.

ALVIN: Then where?

BONGI: I'm taking you up an alley.

ALVIN: An alley!!!

BONGI: Come on, where's your sense of intrigue? An alley's the next best thing to the Casbah.

ALVIN: But what can we do in an alley?

BONGI: You're getting a fast hand job.

ALVIN: For twenty-five bucks!?!?

BONGI: That's it. Take it or leave it.

ALVIN: But a hand job's not quite what I had in mind.

BONGI: It's that or nothing.

ALVIN: But for twenty-five bucks I want more than that!

BONGI: You're behaving abysmally.

Such a nasty, demanding man. You should thank the Lord for small blessings.

ALVIN: But I was rather hoping I'd be given a chance to perform.

BONGI: You'll have all the chance in the world—you can gyrate, moan, groan, oscillate, writhe, and vibrate.

ALVIN: Yeah, I suppose I could, couldn't I?

BONGI: Sure. Here, I'll show you.

(She jumps up and begins to gyrate, moan, groan, oscillate, writhe, and vibrate.)

WAITRESS (hurrying over): I'm afraid I'm going to have to ask you to leave. People just don't go around gyrating, moaning, groaning, oscillating, writhing, and vibrating in the finer restaurants.

BONGI: Can we leave by your alley door? It'll save us some walking.

WAITRESS: Leave any way you want, but leave.

BONGI (*while she and ALVIN walk toward alley door*)**: Just think of this as your *l'affaire d'alley*, Albert.**

ALVIN: Alvin. (*Going out door.*) What was it I'm supposed to do now? Moan, gyrate...

> (His voice fades away as the door closes behind him. After about a minute ALVIN, buttoning up his fly, appears alone at the entrance to the alley between the restaurant and BONGI's apartment building. Immediately after his appearance we hear BONGI's voice from somewhere back in the alley.)

BONGI: See ya, George.

ALVIN: Alvin. (*While ambling dejectedly down the street.*) I guess that performance didn't rate any encores. Well, thank the Lord for small blessings.

> (He walks off. BONGI comes running back around from another alley; then resumes her seat on the steps. She notices someone she knows approaching from down the street.)

BONGI (*shouting*)**: Miss Collins. Hi, Miss Collins.**

(MISS COLLINS, a made-up, bitchy-looking drag queen, swishes on.)

MISS COLLINS: *Hell'o, Angel.*

(He kisses her.)

Pet, you look simply exquisite. You do. You look good enough to eat. Now, tell me how I look.

(He struts and poses.)

Good enough to eat?

BONGI: I couldn't say; I'm a vegetarian.

MISS COLLINS (*noticing someone down the street*)*: Oh, Gawd, look who's... Just ignore her. She is, without a doubt, the most garish, tasteless faggot I've ever run across. I'm ashamed to be seen on the street with her. Look at her—1965 and she's wearing wedgies.*

(SCHEHERAZADE swishes on.)

SCHEHERAZADE: Hell'o, Bongi, Love.

(He kisses her.)

And hell'o to you, too, Miss Collins.

MISS COLLINS: *Don't you dare touch me.*

BONGI: You know, I just noticed—Scheherazade's got an ass like a girl.

SCHEHERAZADE *(excited)*: Oh, *do* I? *Do* I?

(He struts his ass.)

MISS COLLINS: *How 'bout mine? Look at mine.*

(He struts his ass.)

BONGI: Nah, you got a skinny ass.

(SCHEHERAZADE sticks his tongue out at MISS COLLINS.)

MISS COLLINS: *But look at it when I walk; it makes a big difference.*

(He walks and struts his ass.)

BONGI: Nope, it's still a skinny ass.

MISS COLLINS: *All right, so you can't have everything.*

SCHEHERAZADE: What else is there?

MISS COLLINS (*to BONGI*): *You better watch how you sit, Miss Thing; after all, we're still men.*

SCHEHERAZADE: Speak for yourself.

MISS COLLINS: *I face reality, and our reality is that we're men.*

SCHEHERAZADE: You *are* what you look like.

BONGI: You *are* very pretty for a boy.

SCHEHERAZADE (*controlled anger*): What do you mean? For a boy? Look, not to brag, but I know what I've got.

MISS COLLINS: *Do you know where you've got it? It's between your legs.*

SCHEHERAZADE: Ooooo, she's so vile. Miss Trashy-Ass.

MISS COLLINS: *Maybe so, but at least I'd never wear gold eye glitter to an afternoon mixer. Anyway, it's true, true, true, and you know it's true—you'd jump right in the sack after a piece of pussy.*

SCHEHERAZADE (*incensed*): I *AM* a piece of pussy.

MISS COLLINS: *That's just what I've always said—*

you have a face like a twat. Twat Face! Twat Face!

SCHEHERAZADE: Oooooo, I despise faggots.

MISS COLLINS: Shall I tell you a secret? I despise men. Oh, why do I have to be one of them. (Brightening.) *Do you know what I'd like more than anything in the world to be? A Lesbian. Then I could be the cake and eat it too.*

SCHEHERAZADE: You're too insensitive to appreciate the nobility of Dorian relationships. Myself, I've had the most beautiful, inspiring affairs.

MISS COLLINS: Some affairs—three minutes behind a bush, one and a half minutes apiece.

SCHEHERAZADE: I'm *sick* of you always taking something fine and good and making it dirty.

(He belts MISS COLLINS with his purse.)

MISS COLLINS: Don't you hit me, Snake.

(He pushes SCHEHERAZADE hard, causing him to reel backwards.)

Just don't ever hit me.

(He pushes SCHEHERAZADE hard again, causing him to reel even further back. MISS COLLINS keeps pushing SCHEHERAZADE further down the street.)

SCHEHERAZADE: I didn't hit you all *that* hard. You better stop hitting *me*, or you'll be sorry. (*Out of sight.*) Officer, Officer, this thing, she's goosing me with her eyebrow pencil.

(Their voices fade away.)

(A girl in her middle twenties comes out of the apartment building.)

GIRL: Say, Miss, did you, by any chance, see a turd anywhere around here?

BONGI: You mean Alvin Koontz?

GIRL: No, it doesn't have a name; it's just an everyday, run-of-the-mill, anonymous turd.

BONGI: What's it look like? Is it blue?

GIRL: No, no, no, no.

BONGI: Is it green?

GIRL: *No*, no, no, no.

BONGI: Is it red?

GIRL: NO! NO! NOO! NO! Just a
little yellow turdlet.

BONGI: No, I haven't seen it. Not to be nosy, but does this turd have sentimental value?

GIRL: Don't be absurd. It's for
dinner.

BONGI: Oh. Why would it be rolling around out here?

GIRL: I took it out to have
it dyed yellow, and it must've
dropped out of the bag when I was
coming in.

BONGI: Do you often have turd for dinner?

GIRL: You're really too much.
Would you want to be eating
turds all the time?

BONGI: You do have a point there.

GIRL: I'm having company tonight.
I'm having two really dynamic,
fascinating men over for dinner,
and I want to make the best
possible impression.

BONGI: So you're serving them a turd.

GIRL: You're impossible. I
assure you I have no intention,
whatever, of serving my guests
a turd. The turd's for me.
Everybody knows that men have
much more respect for women
who're good at lapping up shit.
Say, would you like to join us
for dinner?

**BONGI: I don't know; depends on what
else is on the menu.**

GIRL: I really couldn't tell
you; Russell's cooking the
dinner. He should be here any
minute now. That's why I do
want to hurry and find the turd;
I thought I'd have it laid out as
a centerpiece before he gets here.

BONGI: If I run across it, I'll let you know.

GIRL: To be frank, Russell's why I'm inviting you to dinner. He doesn't get to meet many girls—I'm his only female co-worker—but I know he'd love to meet some, so, since I've kind of adopted him—he's such a darling boy—I always keep an eye out for him, and you seem to be a nice girl; I think he might like you, and, who knows, you may catch yourself a nice beau. Come on, do join us.

BONGI: Might not be a bad idea; I never did get to eat. Okay, I'll join you.

GIRL: Wonderful. You'll adore Russell; he's extremely talented, absolutely brilliant mind: he writes, very unique outlook—he satirizes women; and he writes the most brilliant essays—you can't understand a word of them. And, to top it all, he's quite the man of the world—he's informed me there's nothing he hasn't done.

BONGI: He means he's been laid.

GIRL: I'll bet even that; he's really quite the sophisticate. By the way, I'm Virginia Farnham, but I much prefer to be called Ginger; it so aptly expresses me—brisk and spicy.

BONGI: I'm Bongi Perez.

GINGER: So nice to meet you, Bongi. Why don't you tell me a little about yourself. What're your vices?

BONGI: I have no vices—I never drink, gamble, or work.

GINGER: Just an old-fashioned girl, I see. I think that's cute. Myself, I'm one of those modern jades—out to get ahead.

BONGI: Ahead of what?

GINGER: Well, you know, ahead, involved in the real world, the world of men, and so far I can't complain; I have a fabulous job—I deal exclusively with men.

BONGI: We have a lot in common—so do I.

GINGER: But I deal with really fascinating men—all neurotic. I adore Neurosis; it's so creative. Create with mental blocks, express your inhibitions—that's my motto. I was discussing this just the other night at a party with Reggie Ronconi—you know, the famous director—and he agreed absolutely. Then we discussed the novel I'm writing—all about a sensitive tortured young man trying to find himself. This novel's the deepest expression of my innermost self. Then I showed him some of my free verse, which he intensely admired. Men have so much better judgment than women.

BONGI: Yeah, they dig women.

GINGER: I must admit my poetry has a certain purity—pure feeling, uncluttered by a single thought, attitude, or idea. Then the conversation got really deep and existential— we discussed freedom and what marvelous freedom it is to be free for sex.

BONGI: And free from it.

GINGER: Oh, we agreed on just everything. We both agreed that a woman with any kind of spunk and character at all doesn't have to choose between marriage and a career; she can

combine them. It's tricky, but it can be done.

BONGI: What's even trickier yet is to combine *no* marriage with *no* career.

GINGER: He and I established the most wonderful rapport. I think he's infatuated with me; he kept grabbing my ass and telling me how different I am. I think he senses the rebel in me. I've always been in rebellion ever since I was a kid. I remember how whenever my father'd tell me to pick my toys up I'd stamp my foot and say "No!" twice before picking them up. Oh, I was a mean one. My latest rebellion is my childhood religion; I've just rebelled against that. I used to be High Episcopalian.

BONGI: What're you now?

GINGER: Low Episcopalian. (*Confidentially.*) Do you know they're even days when I doubt the Trinity?

BONGI: You mean Men, Money, and Fucking?

GINGER: No, Father, Son, and Holy Ghost. What religion do *you* belong to?

BONGI: I used to belong to the Catho-

lics, but I wrote it off when they started talking about demoting Mary.

(RUSSELL, a nicely dressed man about thirty, comes up.)

RUSSELL: Ah, ma petite Gingere', waiting with avid anticipation, I see, for the Great Rucel' to prepare the cuisine extraordinaire.

GINGER (*laughing*): You nut, you.

BONGI: Is this my stud?

GINGER: This is Russell, yes. Russell, I have a surprise for you—this is Bongi Perez, and she's going to join us for dinner.

RUSSELL: Wonderful. Always delighted to meet a charming young lady.

BONGI: The pleasure's all yours.

GINGER: Bongi, you'll love Russell's cooking; he's a master chef.

RUSSELL: All the best cooks're men, you know. This'll be a dinner with virility, hair on its chest, nothing boring and effeminate; it'll be a dinner designed for intrigue and romance. The key to

masculine cuisine is alcohol—overtones of brandy and undertones of rum and wine. Picture it—voluptuous mounds of creamy mashed potatoes bathed in rum gravy, slithering down onto the frapéed asparagus, their tips gently caressing the wine-soaked squid, palpitating in gelatin. And for dessert...

BONGI: Will we be sober enough for dessert?

RUSSELL: For dessert...

BONGI: Besides, we'll all've had orgasms by then.

RUSSELL: For dessert...

BONGI: Rum cake, what else?

RUSSELL: Have you had this dinner before?

BONGI: I don't remember it, but it may be repressed.

GINGER: Where on earth did you ever find palpitating squid?

RUSSELL: It only palpitates in the gelatin.

GINGER: Exquisite imagery. Russell, you're a true artist.

RUSSELL: As well as an illustrious wit. I've thoroughly studied several books on humor and earned a very high score on a humor test, so I can assure you I'm hilarious. I'm also a superb conversationalist; however, it wouldn't be fair to judge my conversational ability by what I say; I don't open myself up too much to people, because, quite frankly, they're no good. One of my more interesting points is I'm very bitter— bitter and, I might add, alarmed; I see very little in our very rapidly, *too* rapidly, changing society that doesn't warrant intensive viewing with alarm. Women, for instance, they'll be the destruction of society.

BONGI: If we're lucky.

RUSSELL: Becoming more aggressive and competitive every day; creeping, slowly but surely, into all the men's fields—law, obstetrics, fashion designing...

GINGER: And there're even beauty shops that're beginning to hire female operators.

RUSSELL: It's positively obscene.

GINGER: Well, you'll like Bongi—she doesn't compete.

RUSSELL: I may very well find her satisfactory—if she's on my level, of course. I've always wanted to meet a girl on my level. Let's see how sharp you are: define "supererogatory."

BONGI: Superfluous; unnecessary.

RUSSELL: Probably luck. What's "comminution" mean?

BONGI: I don't know. What?

RUSSELL: It means pulverization; reduction to fine powder. I suspect I'm a little sharper than you. Define "umbilicate."

BONGI: I give.

RUSSELL: That was an easy one. What's the word sound like? Obviously, it means having an umbilicus. I'll give you one more chance. Define "wimple."

BONGI: I haven't the vaguest.

RUSSELL: It means...

(He hesitates, surreptitiously pulls a two-by-
five card from his pocket, glances hastily at
it, and puts it back.)

... it means ripple. Well, don't feel too badly; you
got the first one right; besides, you're not too bad
looking, or, at least, you wouldn't be if you'd put
a skirt on and look like a woman.

**BONGI: When was the last time you saw
a man with knockers in his sweater?**

RUSSELL: You're evading the issue; men like to
see a little leg.

**BONGI: What makes you think my little
leg's worth seeing?**

(He lifts up her pants leg and peers
at her leg.)

RUSSELL: I think they might be worth seeing.

GINGER: Men like to see a woman look sexy.

**BONGI: Why should I dress to give men
hard-ons? Let them get their own hard-
ons. And if I *was* gonna give a man a
hard-on, I'd give him a nice, fat, juicy
hard-on; I'd show him more than my**

leg; I'd show him my...

GINGER: Please, my reputation's at stake.

RUSSELL: Ginger, your reputation's impeccable in my book.

GINGER: Thank you so much, Russell.

RUSSELL: Ginger's a wonderful woman, one of the truly greats.

GINGER (*laughing modestly*): Oh, really now.

RUSSELL: I never stop being impressed.

GINGER: Oh, come on. You're going much too far.

RUSSELL: No, Ginger, I mean every word of it. Ginger's the only girl on our staff, so she's kinda like a rudder in a sea of restless creativity: calmly and patiently picking up on all the odds and ends that our feverish imaginations let straggle—she researches the data, organizes it, analyzes it, interprets it, composes the reports...

GINGER: But I'm amply repaid. Like the other day Mr. Underhand, our boss, paid me the nicest compliment—he came up to me and

said: "Ginger, I know you're next in line for promotion to associate programmer, but... well... frankly, Ginger, I'd be lost without you, and I know how torn up you'd be if you had to leave us boys, so I'm giving Stewart York the job." And then, his voice almost choked, he said: "We need you too much here, Ginger. I can't let you get away." And then, you know what? A tear actually came to his eye, and I was so touched I burst out crying, and the two of us just stood there bawling away like a couple of kids, and finally I said: "Mr. Underhand, you're nothing but a big baby, just a big, over-grown, rotund little baby." Men're all just little boys at heart.

BONGI: And at brain.

GINGER: But what would the world be without them?

BONGI: I'd like to find out.

GINGER: Myself, I'd be completely lost; I *adore* men.

BONGI: Takes all kinds.

GINGER: I relate so gorgeously to them. I don't like to brag, but I could never get along with

other women; those mincing snots, they turn my stomach. But men never think of me as a woman; they think of me as one of the boys. I'm completely attuned to the gripping dynamism of the male mind. I talk to men on their level; I have virile, potent, sophisticated interests—I adore positions of intercourse, Keynesian economics, and I can look at dirty pictures for hours on end. Men'll flirt around with the snots and tolerate their banality, but when they want a really meaty relationship they turn to me. Take myself and Russell, for instance: he and I have a mutual admiration society going—I venerate his opinions and he has the highest regard for my taste, and I'm flexible enough to've absorbed, not only Russell's, but Phil's and Bob's opinions with equal facility.

(BONGI puts a cigarette in her mouth and strikes a match. Just as she's about to light her cigarette, RUSSELL takes the match out of her hand and blows it out.)

BONGI: You dumb ass! What'd you blow my match out for?

RUSSELL: I was only trying to be a gentleman. I wanted to light it for you.

GINGER: Russell's a perfect gentleman at

all times.

BONGI: You mean he fucks with his necktie on?

RUSSELL: I never fuck; I make love. With me making love's not a sex act; it's a phenomenon. As with everything I do, I take a very cerebral approach to lovemaking, and I don't make love with an amateurish hand; I bring a polish and expertise to my sessions that's the result of painstaking study of the lovemaking manuals. (*Reminiscing.*) **I had a phenomenon just last year, and for all the girls I've phenomened she was, by far, the better.**

BONGI: Come on, come on. You gonna light this cigarette or aren't you?

RUSSELL: I'm trying to find my lighter. Beats matches any day; affords a steady flame, just like a good man. Joke!

GINGER (*laughing*): Russell, you're too much.

> (He lights his lighter, and begins lighting BONGI's cigarette.)

BONGI: That's right, Moron, singe my eyelashes.

RUSSELL: You don't seem to enjoy the little male attentions.

BONGI: I don't enjoy having things snatched out of my hands, and I certainly don't enjoy having my eyelashes singed. Now get that goddamn blowtorch out of here.

GINGER: My, such a vicious attitude. It's disarming. You know, you can get so much more out of life being yielding and feminine.

BONGI: Like singed eyelashes.

GINGER: And like a man to take care of you and protect you.

BONGI: From what? Other men?

GINGER: You know, you have a *very* unhealthy attitude.

RUSSELL: She's sick.

GINGER: Diseased.

RUSSELL: Downright unsanitary.

GINGER: She has penis envy. She should see an

analyst. I'd recommend mine, Dr. Aba Gazavez, a truly remarkable man. You've probably heard of him; he's the famed authority on women and the lending exponent of the doctrine that labor pains feel good. I made his acquaintance through the Marriage and Family Institute where I'm taking a course in Creative Homema-king. Really, I revere that man; I'm on my knees before him.

**BONGI: When I get on my knees
I get paid.**

GINGER: It's so important to have the right analyst. When I first decided to go into analysis I was debating between a Freudian and a Jungian.

**BONGI: Why? What difference does
it make whether you go to the witch
doctor or the snake doctor?**

GINGER: But then I met Dr. Gazavez, and I knew he was for me; he and I share a common value system—we both swear by creativity. He's got this very creative theory about creativity that so beautifully expresses my own crea-tive thought—creative passivity. It's such an uplifting experience once you get the hang of it—relating to emptiness; let your soul sway

41

gently in the void. By peering through the void you attain a pure, uncluttered view of others. You see through to their inner essence. Like take that boy coming along down there... (*Pointing down the street.*) He's a dreamy, sensitive lad; I can tell by the faraway look on his face.

BONGI: He probably has his hand in his pocket playing pocket pool.

(WHITE CAT walks up.)

WHITE CAT: Hey, it's me. I'm back.

BONGI: Yeah, you're the eternal masculine.

WHITE CAT: Some civilization we got—my next-door neighbor was raped and choked to death this afternoon by a delivery boy.

GINGER: Ah, the poor boy. He must've had a rotten mother.

RUSSELL: Probably spent all her time competing. You see what kind of world women create?

WHITE CAT (*to BONGI*): Do you spend all your time loitering on the street?

BONGI: No, I have an occasional moment up the alley.

WHITE CAT: So that's your gig. That's a groovy deal. Sometimes I wish I were a broad, sitting on a gold mine; I'd be peddling it all over town. What're most of them saving it for, anyway? Their old age? But you're smart—making your talent pay off.

BONGI: How would you know what my talent is?

WHITE CAT: What's any girl's talent?

BONGI: Endurance. How else would all you baboons stay alive?

RUSSELL: You women take yourselves too seriously. You can't take a joke.

BONGI: No, I dig jokes. I'm just waiting to get the stage so I can tell *my* funnies.

RUSSELL: By the way, am I correct in inferring from your preceding conversation with this boy that you don't have a job?

BONGI: That's right. I applied for a job once, but they wouldn't pay me enough. I told the guy I couldn't possibly work

for such a stinking salary. He said none of the other girls there mind the salary, 'cause his place's a fun place to work at and 'cause there're loads of bright, handsome, eligible bachelors working there. I asked him if I promised not to marry any of them, could I have more money. He said I didn't have clean values.

GINGER: Tactless of him to've told you.

BONGI: But I couldn't've lasted if they paid me a thousand a week—I'm not a worker; I'm a lover.

WHITE CAT: So am I; that's why I'm a worker.

GINGER: That doesn't make sense; you can't buy love.

WHITE CAT: Love's an itch in the crotch.

BONGI: So why do you need a girl to scratch your crotch? Scratch your own crotch.

WHITE CAT: I'm a sentimental kind of guy; I like togetherness.

RUSSELL (*to BONGI*)**: Isn't your occupation**

rather precarious?

BONGI: It has its ups and downs.

RUSSELL: I mean isn't it rather unstable?

BONGI: What's life supposed to be, anyway? An endurance contest?

RUSSELL: But don't you ever worry?

BONGI: Never about trivialities—like where my next meal's coming from.

GINGER: You know, I consider your calling rather delightful—the artful courtesan, master of all the graces and finesses of seduction. Tell me, what must a woman do to seduce a man?

BONGI: Exist in his presence.

GINGER: Come on, now; there's far more to it than that.

BONGI: Well, if you're in a really big hurry you can try walking around with your fly open.

GINGER: Oh, come on; quit joking. Actually,

I'm sure you must deem it an honor to serve
as high priestess in the temple of love,
fulfilling woman's time-honored role of
pleasing men. We, women, we all have a
little bit of the whore in us.

BONGI: I don't.

GINGER: But most women won't let it come
out. They don't know how to be women;
they've got ice water in their veins.

BONGI: I always thought it was piss.

GINGER: Women should cultivate the whorey
graces. They've lost the feminine charms that
once endeared them to men.

RUSSELL: Too busy competing.

GINGER: One reason why men're so enthralled
with me is they sense the passion, the savage,
the wild beast in me, but restrained, tasteful
passion. Savage that I am, I'm *not* cheap. I'm a
discreet beast.

**RUSSELL: Yes, discretion's the better part of
beastliness, not ferocious clawing away for
dominance, dog-eat-dog competition.**

GINGER (*recitational*): When a woman strives for equality she renounces her superiority. Isn't that right, Russell?

RUSSELL: **Unquestionably.** (*To BONGI.*) **Is that too deep for you?**

BONGI: What do you want to do? Put women back in purdah?

WHITE CAT: We don't need purdah; we have the suburbs.

RUSSELL: You're too easily appeased; you can't see the horror that's creeping up on us. God, sometimes I think it's a curse being sensitive. Marriage—it's their most lethal weapon: before marriage men're active, restless, and energetic.

BONGI: Like a tree full of monkeys.

RUSSELL: Exuberant, vibrant youth.

BONGI: I can guess where they're vibrating.

RUSSELL: But afterwards we're soothed into tranquility, lulled into placidity, devitalized, tamed into submission; they leave us no strength with which to counterattack; they triumph by

depriving us of our most precious possession—
our bachelor freedom.

WHITE CAT: Bachelor freedom, my ass;
that's the freedom of an alley cat—free to prowl
the streets looking for something to fuck.

RUSSELL: Make love to. Well, I will concede
there're a *few* advantages to marriage.

BONGI: Like widows' pensions.

GINGER: And motherhood.

RUSSELL: Ahh, yeeaahh, Motherhood—cute,
cuddly little babies.

**BONGI: Let's all bow our heads and
kitchy-koo for two minutes.**

RUSSELL: A son to carry my name down through
the ages—Fizzlebaum! I'd give anything to be able
to give birth, the crowning achievement, what
every woman's aching for.

BONGI: I'm not.

GINGER: How would you know? You're not a
specialist.

RUSSELL: The highest honor, the supreme power.

GINGER: The hand that rocks the cradle rules the world. Isn't that right, Russell?

RUSSELL: It's indisputable.

BONGI: That's a slick little maxim— while the hand's rocking the cradle it won't be rocking the boat.

GINGER: There're plenty of male hands around to do whatever boat rocking's necessary.

BONGI: I've met quite a few hairy old male hands in my day, and it's not the boat they're grabbing for.

WHITE CAT: Why should it be? It's a man's world.

BONGI: Only by default.

GINGER: Default or not, I think it's marvelous.

WHITE CAT: Sure, in a man's world you broads have the ultimate weapon—sex.

BONGI: Then how come we've never had a sexy president?

WHITE CAT (*to BONGI*): Why don't you run for president?

BONGI: Nah, I like to think big.

GINGER: Personally, I'd hate to see a woman president.

WHITE CAT: Why? Women're just as good as men in every way.

BONGI: I've had just about enough of your insults.

GINGER: Well, whether they are or not, we'll never have one. Never! We never have... (*So-there voice.*) and we never will. Will we, Russell?

RUSSELL: It's unthinkable.

BONGI: Maybe being president wouldn't be such a bad idea: I could eliminate the money system, and let the machines do all the work.

WHITE CAT: Thanks for the warning. I'll be sure to not vote for you. Sure, I'd like to not need bread—I don't want to have to combine marriage and career—but the broad's gotta need it. You know the S in the dollar sign? That stands for sex.

GINGER: Actually, there's something to be said for Bongi's system; men need leisure time.

WHITE CAT: What'll I do with all that leisure? Lay around with a big hard-on?

GINGER: It's a sin to tie men down to jobs. Men're the hunters...

WHITE CAT: Yeah, I been doing a lot of that.

GINGER: ...the adventurers; they should be free to go off and invent and explore, soar off into the unknown.

RUSSELL: And leave the kids to the women? Corrode my son with femininity? Never! When mothers aren't competing they're mothering; you gotta keep a close watch on them. I want my son to be the best of all possible men.

BONGI: You mean a half-assed woman.

RUSSELL: When he grows up I want to be able to point to him and say: "There goes my son—the man." I want to live in a masculine culture.

BONGI: That's a contradiction in terms.

RUSSELL: I want a strong, virile environment.

BONGI: Why don't you hang out at the YMCA gym?

WHITE CAT: The battle of the sexes—it's been raging on for centuries.

BONGI: I know how we could eliminate it.

WHITE CAT: How?

BONGI: Have you ever heard of sex determination?

RUSSELL: Never! Never! That's not natural. There'll always be two sexes.

BONGI: Men're totally unreasonable; they can't see why they should be eliminated.

RUSSELL: No! The two-sex system *must* be right; it's survived hundreds of thousands of years.

BONGI: So has disease.

RUSSELL: You can't just determine us away. We won't allow it; we'll unite; we'll fight.

BONGI: You may as well resign yourself: eventually the expression "female of the species"'ll be a redundancy.

RUSSELL: You don't know what a female is, you desexed monstrosity.

BONGI: Quite the contrary, I'm so female I'm subversive.

RUSSELL: Well, I, for one, wouldn't make love to you for a million dollars.

BONGI: Maybe not, but you'd do it for nothing.

RUSSELL: Never! Not if you were the last woman on earth.

BONGI: That's not your decision to make.

RUSSELL: That's ridiculous. Whose decision is it?

BONGI: Mine.

RUSSELL: I think I just might have *some*thing to say about it.

BONGI: You have *noth*ing to say. When I give the signal you'll jump.

RUSSELL: You have some unmitigated gall.
Who do you think you are?

BONGI: Just a girl with a signal. Here,
I'll show it to you.

 (She starts to undo her belt.)

RUSSELL: I don't want to see anything you have,
Slut.

BONGI: Yes, you do, and I'm gonna do
more than *show* it to you; I'm gonna
give it to you.

RUSSELL: I don't want it.

BONGI: Yes, you do.

 (She pulls her pants down while moving
 behind a bush, but in view of RUSSELL.)

You and I're gonna do it right now right
here.

RUSSELL: You wouldn't dare.

BONGI: Come and get it.

 (He approaches hesitantly; then retreats.)

RUSSELL: No!

BONGI: Come and get it.

(He approaches hesitantly; then retreats.)

RUSSELL: No!

BONGI: Come and get it.

WHITE CAT: If you don't hurry up and go get it, I will.

BONGI: Come and get it.

RUSSELL: I could never make love to you; you have no mystery.

BONGI: That's right; when I give it to you, you *know* you're getting it.

RUSSELL: No, I could never make love to you, but I *am* louse enough to screw you. You deserve it, you piece of filth.

(He lunges toward the bush.)

GINGER: Russell, you're so masterful.

BONGI: No, wait. First get on your

knees and say: "Please, can I do it to you?"

(He gets on his knees.)

RUSSELL: Please, can I do it to you?

BONGI: You're a good doggie. Yes, you may.

(He goes behind the bush and does, while GINGER and WHITE CAT watch.)

GINGER: She's way overreacting; sure sign of a defense mechanism.

WHITE CAT: But that's some swinging mechanism.

GINGER: But let's face it—what man could ever respect her? Russell, I must admit your style's exquisite.

RUSSELL (*from behind the bush*): **Note the form.**

GINGER: A symphony of movement.

RUSSELL: And the control.

GINGER: Yes, control, the essence of freedom.

Russell, how I envy you, the way you just let yourself go, free as a bird, free to express yourself with carefree abandon, the soaring male spirit.

WHITE CAT: There's another bush over there; we could soar behind that and really let go.

GINGER: Live! Live! Live! That's my motto. Feel life coursing through your skin. Be completely absorbed in it.

BONGI (*from behind the bush*)**: Well, you can't complain; you've been sucked in quite a ways.**

GINGER: Oh, hey, Russell, what's that protruding over there?

RUSSELL: You mean this?

(He throws out a brown paper bag.)

GINGER: Russell, you darling, you've found my turd. (*Clapping her hands and jumping up and down.*) You've found my turd! You've found my turd! This calls for a celebration dance. Never pass up a chance to be creative. I'll call this dance Dance for a Turd.

WHITE CAT: Swinging. Shall I come piping in with a few farts?

GINGER (*patient indignation*): This is to be a creative production, and will be approached with sensitivity and feeling or not at all.

WHITE CAT: I could keep 'em low-keyed.

GINGER (*restrained sternness*): There will be *no* farting. This dance'll consist of variations on the dance of dances, the dance par excellence—the belly dance.

RUSSELL (*emerging from behind the bush*):
According to a highly abstruse anthropology book I read when I was only ten, the belly dance requires painstaking, exacting control, and, therefore, could only have been invented by a man.

GINGER: Russell, now that you're back, would you run inside and put on one of my belly-dance records?

RUSSELL: No trouble; I was going in anyway; I want to start soaking my squid.

(He picks up his bag of groceries, and goes inside.)

GINGER: The belly dance is actually the highest pinnacle of artistic expression; it's art boiled down to its essence...

WHITE CAT: Sex.

GINGER: I do believe we share a oneness. I sensed that when I peered at your face through the void. Your face reflects your inner essence.

BONGI (*emerging from behind the bush*)**: Yeah, fuck face.**

GINGER: Peer into *my* face, and what do you see?

BONGI: *His* ugly face.

GINGER: There're no ugly faces, only ugly souls. This dance'll be the very deepest expression of my innermost self, the very essence of me.

(The music begins.)

BONGI: Here it is, Ladies and Gentle-men... (*Ta-da voice.*) **The *Be*lly.**

(GINGER belly dances, intensely and with essence.)

WHITE CAT: Hey, she's pretty swinging.

BONGI: Yeah, from the trees with the apes.

WHITE CAT: She and I could really groove together; I swing like crazy.

BONGI: Only thing swinging about you is your balls.

WHITE CAT: I got news for you, Baby—I'm a real man.

BONGI: Yeah, that's the trouble. (*Studying GINGER's dancing.*) **You know, that's not half bad for one of the boys.**

WHITE CAT: What'dya mean for one of the boys? I can do that.

(He does.)

BONGI: So can I.

(She does.)

I got a belly to end all bellies; it's a belly's belly; I got a snake tattooed 'round my navel, and when I get really wound up it

hisses at you. Ssssssssss. If we were in a more discreet setting, I'd show it to you. I have talent everywhere you look. (*Watching WHITE CAT, but still dancing.*) **Oh, snake it, Boy.**

(He snakes it.)

Sweetie, if you're not, you sure as hell ought to be.

WHITE CAT: Ssssssssss.

BONGI: Oh, say, you're a bitchy one.

(They shimmy, shake, and snake it up.)

Hey, do you do that well in bed?

WHITE CAT: Where d'ya think I learned?

BONGI: I'm Blitzina, the lightning goddess, zigzagging a dazzling path through the heavens.

(She zigs her zag.)

Hey, you oughta see my Dance of the Seven Towels sometime—after ripping off the seventh one, I soap

myself up, work myself into a lather, then the chorus girls, all wearing shower caps, flog me offstage with wet washrags. Then there's my modernistic fan dance—I use an electric fan.

WHITE CAT: Where d'ya plug it in?

BONGI: I have a built-in generator. For my grand finale I short-circuit myself before your very eyes.

WHITE CAT: Sounds shocking.

BONGI: I get a big buzz out of it.

(They snake it up, shake and shimmy.)

The lightning goddess heaves a mighty bolt and sizzles all in her path.

(She pulls her arm back and swings it forward in a wide arc, ending by goosing WHITE CAT, sending him sailing several feet away. GINGER stops dancing, and looks around upsetly.)

GINGER: Russell! These Philistines! They're trampling on ART!

(SPADE CAT walks up.)

SPADE CAT: An unpardonable affront to the sensibilities, one which I view with mammoth disdain and horror. If I may say so, that was a superb belly dance you were doing. I'm a connoisseur of bellies, and I can look in your face and see that yours is unique and highly distinctive.

GINGER: Why, yes, it is; it's so me. You know, you're quite perceptive.

SPADE CAT: Years of professional contact; I happen to be an agent for belly dancers, and I think I may be able to do something for you.

GINGER: How *interesting*. I've always known I'd be discovered.

SPADE CAT: I'd like to suggest we adjourn to my pad where we can peruse your belly at our leisure.

GINGER: If it's not putting you out too much, I'd love to.

SPADE CAT: If it'd make you feel better, I could charge you my examination fee.

Come on, we'll discuss it on our way.

(They walk off together, chatting as they go.)

GINGER: Do you know Reggie Ronconi, the famous director?

(Their voices fade away.)

WHITE CAT: Where've I failed? Didn't she say she and I shared a oneness? Didn't she peer at my face through the void? (*Anguished.*) Then what's the reason?

BONGI: How'd you like me to invite you to Russell's dinner? That might make you feel better.

WHITE CAT: That'd be some consolation. There gonna be anything special?

BONGI: Yeah, a turd. Come on; let's go.

(She picks up the brown paper bag, and they go inside. There's a complete blackout, followed by a spotlight on a middle-aged woman, TEACHER.)

TEACHER: Well, I see the class is already assembled. I hope you're all in the right room. This is Creative Homemaking, sponsored by the Marriage and Family Institute, headed by Dr. Aba Gazavez. Marlene, I see you're taking our course again. I think it's marvelous, Dear, that you're so conscientious about homemaking. Everyone of you girls, presumably, is a future homemaker of America? Good. Let me begin by congratulating you for choosing the most challenging, most fulfilling, most ennobling profession that man can possibly dream of—homemaking, a profession demanding a solid character, a solid heart, and a solid mind—made of rock. In other words, to be a successful homemaker a girl must have rocks in her head. Now, let me tell you a little about the Marriage and Family Institute's philosophy: we're dedicated to the belief that marriage should be FUUNN! FUUNN! FUUNN! but responsible fun, the fun that derives from duty and sacrifice. Marriage is not to be undertaken frivolously; it requires a mature, fully developed dependency and a vast capacity for endurance. For that reason the Marriage and Family Institute deplores the current trend toward early marriage; we don't believe a girl of eighteen, twenty should rush into marriage and stunt her growth; she should wait until twenty-five, thirty or so, *then* stunt her growth. Oh, by the way, you might inform some of your already-married friends of our marriage counseling service.

Our counseling service has been a really whopping, huge success—we've kept some of the most incompatible couples together. Now, a word or two about the aim of our Creative Homemaking course.

The Marriage and Family Institute deplores the fact that girls enter marriage with no preparation whatsoever. If you were going to be a doctor, you'd receive years of intensive training, wouldn't you? Of course you would. Isn't it only common sense, then, that you receive at least as much training for the infinitely more demanding profession of homemaking? Why, it's too obvious to debate. So the aim of this course, then, is to compensate just a teensy bit for the enormous gap in the future homemaker's education. The facets of homemaking we'll delve into in this and future classes will be the most important ones of cooking, marketing, budgeting, dusting, child-rearing, and fucking. Fucking, I hope you girls realize, is not to be undertaken frivolously. It's man's noblest, most mature expression of love (while doing it, one must always think of love). Fucking's not a child's game; it requires great maturity and a fully developed character to fully enjoy tearing off a piece. This being so, it might be appropriate to devote the first of our little sessions in Creative Homemaking to creative fucking. To be truly creative one must be integrated, and, likewise, for homemaking to be truly creative all facets of homemaking, including fucking, must be integrated with each

other. We don't want homemaking to be just a series of fragmented, unrelated activities, do we? This, of course, doesn't mean you're to go around fucking while tending to your other homemaking duties; that might prove rather burdensome, as well as setting a bad example for your children, who, after all, won't be quite ready for homemaking. What integrated fucking *does* mean is relating fucking to your other homemaking activities. For instance, while baking your cakes and cookies you can remind yourself that very shortly you'll be getting *your* cookies; or to relate fucking to marketing you could try fucking the grocery-store clerk, but that, of course, would be adultery, which, as we all know, is a sin. The Marriage and Family Institute does *not* encourage adultery, nor do we encourage masturbation, Marlene, so get your hand away from your little thing. That's what marriage is for. Now, let me give you just one more example of integrated homemaking activities, and you can see just how exhilarating truly creative homemaking can be. Integrate your sex life with baby-bottle washing: wait until hubby's getting ready to take his bath; then, quick, soap up the baby-bottle brush, working it up into a nice, foamy lather; then when hubby's all nicely naked and is leaning over to test his bath water, you come te-e-a-a-r-r-ing in... (*Demonstrating.*) r-a-a-m-m-ing the brush right up his asshole. So, you see, Girls, marriage really can be fun. But before your

marriage can soar away on wild, creative flights of fancy, you must first master the fundamentals, and that's precisely what we're going to learn here today—basic fucking. Marlene, would you go out in the hall and tell the boys they can come in now? Thank you. All right, Boys, I hope you all brought your mats and cundrums, as I requested. Fine. Now get your partners, and, please, no talking when fucking begins. Allll right, Everybody, watch Teacher. Position A. (*Getting into position A.*) *One*, two. *One*, two. You see how it's done? Allll right, begin. (*Clapping her hands.*) *One*, two. *One*, two. *One*... Marlene! No, no, no, Marlene; you're one-ing when you should be two-ing. Now let's try again. *One*, two. *One*, two. Th-a-a-a-t's right. *One*, two... (*Almost at the end of her patience.*) Marlene, would you please confine yourself to fuck-ing. The Marriage and Family Institute doesn't exist to turn out prostitutes, just simple, basic, ser-viceable wives. Now, back to fucking. Watch me, now. *One*, two. *One*... (*Barely controlled exaspera-tion.*) Marlene, stop tweezing the hairs out of your partner's ass; that's entirely irrelevant to creative homemaking. I mean, after all, you can carry even creativity just a little bit too far. Marlene, you've so completely frazzled my nerves, that'll have to be all for today. But before I dismiss you, Class, may I remind you that marriage is a sacrament, and in keeping with the divine nature of marriage I'd like to end our fucking session with a short prayer:

(*With deeply felt reverence.*) **Oh, God, Our Father, Son of the Holy Ghost, Husband of Mary, give us this day our daily cookies, but, most of all, make our marriages FUUNN! FUUNN! FUUNN! Ah-men.**

(The spotlight goes off of TEACHER, leaving the stage blackened. The lights then go back on, revealing BONGI seated on the steps. A woman in her middle or late twenties passes her.)

BONGI: Hey, Dishrag.

WOMAN: If you're calling me, my name happens to be Mrs. Arthur Hazlatt.

BONGI: Arthur?! That's an odd name for a woman.

ARTHUR: That's not my name; it's my hus band's.

BONGI: Well, now I know what to call *him*; what'll I call you? I think I'll stick to Dishrag; it's as appropriate as Arthur.

ARTHUR: You're not gonna call me anything, because I'm not gonna stick around to be

called. I don't want anything to do with you.

 (ARTHUR starts to walk away, but BONGI grabs her arm.)

BONGI: You're not going anywhere, Dishrag; you're gonna stay right here and fight.

ARTHUR: Are you crazy? Why?

BONGI: What's a Dishrag for? To wipe things up with, right? Well, that's what I want to do with you—wipe the street up with you. I want to help you fulfill yourself as a dishrag.

ARTHUR: You're awfully smug. What makes you so sure I won't wipe the street up with you?

BONGI: I'm not a bit sure. Shall we find out?

ARTHUR: I fail to see what this'll accomplish.

BONGI: This could be the beginning of a beautiful romance; one shared experience is all it takes.

 (A boy about five or six wearing a three-quarter-length coat comes

whining, bawling, and screaming up.)

BOY: Ma, can I go with you? Please, Ma.

ARTHUR: What're you doing up here? You're supposed to stay on the playground.

BOY (*sobbing*): **The playground lady told me I couldn't stay.**

ARTHUR: Why?

BOY: 'Cause my dinghy's hanging out.

ARTHUR: Well, put it back.

BOY (*choked up*): **I can't.**

ARTHUR: Why not?

BOY (*sobbing*): **'Cause it's got glue all over it.**

ARTHUR: How in the world did you get glue all over your dinghy?

BOY: I was trying to make it stiff like Joey's brother's.

ARTHUR: Didn't you explain that to the lady?

BOY: Yes, but she still told me to go home. She says she runs a very creative playground, and she can't integrate me into the activities… (*Breaking up.*) with my dinghy hanging out.

ARTHUR: *Well, you go on back and tell the lady you'll be happy to put your dinghy back, if she'll de-glue it.*

BOY (*screaming*): N-N-N-O-o-o-o. I wanta go with you.

ARTHUR: *Well, you can't go with me. Now go on back to the playground. She's a nice lady, and she'll be glad to de-glue your dinghy.*

BOY (*sniveling off*): All right for you. A lot you care about me, sending me off with my dinghy in this condition. I hope this happens to you someday. See if I'll have any pity on you. I'll just stand around and laugh at you. Ha, ha, ha, ha, Ma's dinghy's hanging out, and it's got glue all over it.

(His voice fades away.)

ARTHUR: *That's the only thing I ever*

experience. You wanta share that with me?

BONGI: No, thanks. I'd prefer a belt in the mouth.

ARTHUR: You know something? So would I. I'm one of society's rejects—a wed mother. Imagine me dumping my kid onto the city to raise; who'd speak to me? I'm not even entitled to any sympathy; like, you know, the magic metal band around your finger transfers mistakes into blessed events. There oughta be a special home for wed pregnant girls; as it is, we not only have our pregnancies to put up with, but husbands too.

BONGI: Why do you *have* to put up with him?

ARTHUR: Well, you know how women are— loyal, faithful, dedicated, and reliable.

BONGI: Yeah, and they oughta get slammed right in the teeth for it.

ARTHUR: Besides, the kid needs a father.

BONGI: Needs him for what?

ARTHUR: Oh, I don't know. If he didn't have one, he might grow up and be a faggot or something.

BONGI: That'd be just as well; let the guys ram each other in the ass and leave the women alone.

ARTHUR: Who wants to be left alone? I was left alone for years when I was single. You know, I was one of those nice girls—I never screwed—'til I got married, then did nothing but.

BONGI: I find that rather shocking. I mean it's indecent. There's something in terribly bad taste about married people screwing.

ARTHUR: Each other anyway.

BONGI: I can see a couple of kids going off and getting laid, but you'd think people old enough to be married would've matured beyond that stage.

ARTHUR: I am terrible, aren't I?

BONGI: You're evil.

ARTHUR: I feel so degenerate.

BONGI: Downright perverse.

ARTHUR: But what else is there? I've been to Dr. Gazavez; I've tried relating to emptiness, but it doesn't work—he doesn't relate back.

BONGI: Men're so fucking crude.

ARTHUR: Yes, but I try to demonstrate a little compassion; after all, people can't help being what they are.

BONGI: Neither can germs.

(The little boy comes running up.)

BOY (*panicked*): **Ma, I can't pee; I can't pee.**

ARTHUR: Why not?

BOY (*still excited*): **My pee hole's all clogged up with glue.**

ARTHUR: Didn't you ask the playground lady to de-glue you?

BOY: Yes, but it was snack time, and she was in the pantry house getting the milk and cookies out.

ARTHUR: So?

BOY: She said she can't be bothered with dinghies while she's getting her cookies.

ARTHUR: Well, I'm sure she's finished getting her cookies by now. Go on back and ask her again.

BOY (*grabbing her skirt, desperate*)**: N-o-o-o-o-o, Ma, let me stay with you. PLEASE!!**

ARTHUR (*sternly*)*: No, you can't stay with me; I'm going shopping, and I don't want you along bugging the hell out of me, and, anyway, you can't go downtown with your dinghy hanging out. Now get back to the playground.*

BOY (*jumping up and down, hysterical*)**: But there's glue all up my pee hole!!! You can't just leave me here with glue all up my pee hole.**

ARTHUR (*top-sergeant voice*)*: Get back to the playground.*

BOY (*with great emotion*)**: It's getting further and further in; it'll never come out.** (*Anguished.*) **I'll have to go through life with glue all up my pee hole!!**

ARTHUR: GET BACK TO THE PLAYGROUND!!

BOY (*going off, sniveling*): **You'll be sorry some-day; I'll grow up and you'll have to say: "There goes my son—there's glue all up his pee hole."**

(His voice fades away.)

ARTHUR: I'm going shopping for a birthday present for Teddy Bear. That's my pet name for my husband, a fuzzy, inanimate object that I hug 'cause there's nothing else around to hug. I'm getting him a pair of monogrammed screwing pants; they're toreador pants with a slit in them. I make him wear them when screwing, so I don't have to look at those big, hairy, apey legs and skinny ass. I want to get them today, so he'll have them for tonight's affair. We have an affair every Tuesday and Saturday night from 12:00–12:02 and sometimes an afternoon quickie. We had one this afternoon, but I coughed and missed it.

BONGI: Try Smith Brothers.

ARTHUR: If they're better'n my husband I just might; I've been thinking of branching out a little. This screwing bit really gets to you; it gets in your blood. You know, you get to the point where you think Fuck. All day and all night I keep dreaming of the Big Fucker. It gets

77

to be an obsession. I finally got to the point
where I kept seeing ghost fuckers in the sky.
I'm cut out to be a real swinger; I want to
really travel, really move.

BONGI: But all the motion'd be in your ass.

*ARTHUR: Where else? Sure, I'd like to do
something radical and daring—like think,
but you have to make a few concessions, if
you want to live in society, so I have sex and
collect antiques; I kinda like musty things from
out of the past.*

BONGI: You mean like men.

*ARTHUR: You might say that; men do have a
naturey aura about them; when they're around
Fuck is in the air; it's overpowering; it carries
you away with it, sucks you right up.*

**BONGI: Very fucky world we live in.
My only consolation's that I'm me—
vivacious, dynamic, single, and a queer.**

*ARTHUR: Oh, you're one of those. I've always
wanted to meet one of those. What say you
and me ball tonight? I'll bet you'd be a crazy
lover.*

BONGI: Actually, I'm a lousy lover—I'm too good a talker.

ARTHUR: Ah, come on; I'll bet you're a titillating bundle of eroticism.

BONGI: I used to be, but I'm all titillated out. I decided I want to live on my feet, not on my ass. And, anyway, you're not my type.

ARTHUR: Too bad; I'd love to get you alone.

BONGI: That's why you're not my type; I can't be gotten when alone.

ARTHUR: You mean you like to do it in public?

BONGI: Do what?

ARTHUR (exasperated)*: Whatever's to be done.*

BONGI: Must something always be done?

ARTHUR: Well, it does put a little zing into life. How the hell do you spend your time, anyway?

BONGI: Well, when I was a kid I hung around the street; then I got more sophisticated—I hung out in bars; now

I'm more sophisticated yet—I hang
around the street.

ARTHUR: But don't you have any private life?

BONGI: No such thing.

*ARTHUR: What're you, a Communist or
something?*

BONGI: I'm a very people person. You
know what really flips me? Real lowdown,
funky broads, nasty, bitchy hotshits, the
kind that when she enters a room it's like
a blinding flash, announcing her presence
to the world, real brazen and public. If
you ever run across any broads who look
like neon lights, send 'em my way.

*ARTHUR: Send 'em your way? From now on
I'm in business for myself.*

(The little boy is heard screaming and
bawling up the street.)

ARTHUR: Here comes that little prick again.

(He walks up, still bawling.)

BOY (*whining*): M-a-a-a-a.

ARTHUR: *Go swing on a live wire, will ya?*

BOY (*still whining*)**:** Ma, please let me go with you, please! My dinghy, it's...

(ARTHUR grabs the boy by the throat and squeezes it. Snarling, her closed teeth bared and her eyes bugged, she picks him up by the neck and hurls him to the ground, squeezing hard all the while.)

BOY: Aaaaaack, glaaaaaack.

(His face turns blue; she continues to squeeze for another fifteen seconds; she then throws him to the ground, picks up a garden shovel lying near the bush and begins to dig behind it.)

BONGI: Not here; it'll attract dog shit. There's enough turds rolling around here as it is.

(ARTHUR chooses another spot further back near the building, digs furiously, picks up the boy, throws him in the hole, and shovels the dirt on top of him.)

BONGI: You're a good head, even if your name *is* Arthur.

(ARTHUR finishes shoveling and comes back to where BONGI's loitering. A low-down, funky broad passes.)

ARTHUR: *Hell'o, you beautiful, low-down, funky doll.*

(The DOLL continues walking down the street. BONGI and ARTHUR follow along behind her.)

BONGI (*to DOLL*): **Hey, you like to meet my seester?**

DOLL: Why not? I have an eye for the ladies.

(By this time they're out of sight.)

ARTHUR (*from down the street*)**: *What's the other eye for? Whores?***

(Their voices fade away.)

THE END

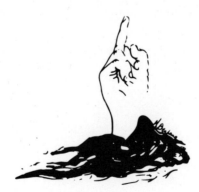

Valerie Solanas (1936–1988) was a writer whose 1967 *SCUM Manifesto* has become an iconic if controversial text in the canon of radical feminism. In 1965, she completed *Up Your Ass* and hitchhiked from Berkeley to New York City, where she intended to stage it. However, the New York theater world was not receptive, nor was Andy Warhol, whom Solanas approached in 1966 in the hopes that he would support her project. Faced with serial rejection, she ended up self-publishing the play, and cast and staged a live reading in 1967. In 1968, at a breaking point (later diagnosed as a schizophrenic episode), Solanas shot Warhol, for which she served three years in state mental institutions. She spent much of the rest of her life destitute and afflicted by paranoia, though she continued to write, and for a period worked as an editor at *Majority Report: The Women's Liberation Newsletter*. To date, *Up Your Ass* has only been produced for the stage once, in 2000, by George Coates in San Francisco, just blocks from where Solanas died.

Valerie Solanas
Up Your Ass

Published by Sternberg Press

Graphic Design: Roxanne Maillet
Cover Lettering: Marie-Mam Sai Bellier
Proofreading: Max Bach
Printer: Tallinn Book Printers

ISBN 978-3-95679-605-0

Distributed by The MIT Press, Art Data,
and Les presses du réel

Sternberg Press
71–75 Shelton Street
London WC2H 9JQ
www.sternberg-press.com

MONTANA

Edited by Leah Whitman-Salkin

Montana is a propositional series exploring the adjacencies of the literary and the visual, the poetic and the political. Deeply invested in the production of a radical present and future, the books of Montana form an ecology of thought that is connected in spirit, practice, and language, yet distinct and diverse, spanning geographies and time.

Diamela Eltit
Custody of the Eyes

Valerie Solanas
Up Your Ass